ARROW OF SUCCESS

A Boy's Growth into Modernity in Africa

WRITTEN BY

AZURAGO JONAS ANAFO

Arrow of Success | Azurago Jonas Anafo

Copyright © **2016 Azurago Jonas Anafo**

This book is licensed for your personal enjoyment only. This book may not be re-sold or given away to other people. Thank you for respecting the hard work of this author.

Self-published in Accra, Ghana

For Bulk Purchase

Please call: *+233265178215*

Book Cover Design & Layout by:

The SEDI, +233242720010

PREFACE

Nothing is more pleasant to a child than growing up in the Upper East Region of a West African nation, Ghana. We usually gathered around my grandfather listening to folktales, seated in an orderly manner like individuals in an auditorium of American theatre hall of fame. Nature compensated our family clans and larger society of some degree of ignorance and destitution. Families and clans handle each other's problems collectively, devoid of discrimination. Family properties such as cattle were kept safe (just as Westerners operate joint account), for dowering and funeral activities.

For this young guy who was about to bury his parents, it was different altogether. So I asked myself, where is the old time religion of love, unity and comfort that dwelt among families? In our world of today, when one is mourning, his or her close relations might pretend to be mourning alongside with them. However, some of these people have ulterior motives. Widows and orphans are more vulnerable during such periods. In this novel, the protagonist achieves his aim not using a radical method but Civilization to bring about societal transformation.

Azurago Jonas Anafo

ACKNOWLEDGMENTS

Putting this manuscript together would not have been possible without life and health which is an unmerited favour from the Almighty God through Christ Our Lord.

There were sleepless nights and uncomfortable moments. The conception within me had to be born so that men of this generation and posterity would benefit.

I am most grateful to a brother who sailed with me throughout the entire process. You helped in editing and giving inputs thus making the product ripe. May God Almighty enlarge your coast, Mr Moses Awinsong of Eastern Illinois University, USA.

My depth of gratitude also goes to my cherished wife (Ms Rosemary Agyeiwaa), lovely daughter(Azurago Happiness Adeeyande), my mum/editor(Cecilia Mwaab), sisters (Charlotte, Victoria)and their families, sister Patience Nyandeba, bro Peter, the entire Azurago family, friends, and love ones for making this write-up a success.

I am also highly indebted to Mr. Wilson Ayinbangya Amooro a comrade in the writing business for helping me in the publication process. To my Artist, Mr Siddiq, I say thank you.

INTRODUCTION

Atule was in a good mood until he was told he had a call at the school booth awaiting his answer. He was forced to truncate the sumptuous jollof meal he was enjoying in the dormitory. The statement "you are needed home" increased his state of suspense after answering the call that faithful day. Whilst contemplating the import of that statement from his uncle, Atule however remembers his father's observation that brisk speaking in parable among Africans foreshadows unpleasant information.

With that foreknowledge Atule prepares himself both mentally and financially to set off for home. Apam, Atule's roommate exhibits the virtue of love as a true African by granting him some financial help against any eventuality at home.

Whilst heading toward Teshie (his village), Atule gets a lift from Atibil who attempts to ask him a question but does not complete, thus; "are you just arriving for the ……?" Atule replies by saying "for what?" Atibil prevented himself from falling foul to the laid down principles of custom highly esteemed in Africa.

The sound of the griot's instrument – goge, and the invasion of the entire compound by different people made Atule's perception conclusive. It was now obvious that, someone is embarking on a journey to an ancestral world. His mastery of courage to follow the customary procedure of greeting the elders before any sad news is broken to him, makes him a true African. After knowing that he had lost his father, he prepares himself psychologically to assume that role.

Arrow of success thus takes a look at this poor African boy who struggles through 'thick and thin' to become a successful person.

Holding the quill with a frail hand
The ink drops with powerful sounds
Echoing to men of wicked hearts
Orphans and widows they must jealously guard
If their hearts remain in their wicked states
The ink will dent their worthless dreams.

Azurago Jonas Anafo

DEDICATION

I dedicate this piece of work to all Widows, Orphans, and cherished readers and to my late Dad, **Mr. Edward Abugri Azurago.**

Table of Contents

Preface	03
Acknowledgments	04
Introduction	06
Dedication	09

Chapter One 12
The Funeral Rites

Chapter Two 25
The Burial

Chapter Three 41
The Final Funeral Rites (Dry Funeral)

Chapter Four 54
Unroofing the Grave

Chapter Five	65
Amaltis' Desire	
Chapter Six	71
Mbama's Bride Price	
About the Book	77
About the Author	78
Glossary	79

CHAPTER ONE

THE FUNERAL RITES

Atule, held his spoon to fetch the jollof from the stainless steel plate which he supported with his right hand.

"So, you still eat with your left hand?"Apam queried. Amongst the Kusasi and in most parts of Africa, eating with the left hand is prohibited. One who does so is considered disrespectful in most cases. One dares not present something to someone, more especially an elderly person, with the left hand.

"No" Atule answered, "How was the obstetrics lesson today? I realized even you of all people were bored to the bone. I guess this new lecturer is going to do the talking alone because no one seems moved by his teaching methods."

Apam, "I was as bored as a drowsy pregnant woman of whom I was supposed to be learning. I was completely disinterested." Apam was Atule's roommate. They had met the first time when both were paired in the same room.

The manner in which Atule eyed the food and the rhythmic movement of his gullet showed that the meal, his second of the day after the breakfast porridge with groundnut, was sumptuous. At this nurses' college, tuition usually starts as early as 7:00am. Students would sit for a two hour lecture before they would go for breakfast. Today was not different. The second leg of

lectures would take about four hours. For this reason, students who could afford opt for bought meals. But Atule hardly did. He has been attending this college for two years with the little resources the family could gather.

Atule usually budgets half of his student financial allowance of forty seven cedis for his family. He is left with a budget to message between toothpastes, bathing soap, pomade and his upkeep. Maslow's theory of needs becomes completely practicalized in Atule's small college bed. This theory, which teaches one to prioritize one's needs, came in handy for Atule. Might his faint faith have played a role in his decision to share the little he has with the family? Most people who watched him carefully usually nod their heads in wonder because he does not act according to his name. Atule means 'opposite' in the Kusaal dialect. The story surrounding his birth had it that he came out with his buttocks which in obstetric is termed breech.

In Kusasi tradition, as in other parts of Africa, it is believed that an individual acts according to the name he or she is given. Atule however behaved differently. This same Atule had a mate in class called 'Ayelatoya' which literally means,'the one whose matter is hard.' True to his name, Ayelatoya was a troublesome person. Apart from naming a child according to the circumstance surrounding its birth, a child could also be named according to the day in which it is born. A child born on Sunday is called Alahari, Monday-Ateni, Tuesday-Atilata, Wednesday-Alariba, Thursday-Alamisi, Friday-Azumah, and Saturday-

Assibi. Other names may be given based on circumstances and proverbs. The name Asore means 'the one who was born by the road."Adaah means 'one who was born at the market. 'Thus names held a symbolic meaning among this people. A name could provide inspiration for greatness or for failure for many a young person.

Atule had done just one-quarter (¼) of the entire plate of food. He swallowed each spoon full like muzzles of 'saab,'a hotly stirred millet staple. The smile on the faces of himself and his roommate gave an impression that the meal was palatable. Sweat was dropping profusely like a leaking tap all over his body. Occasionally, he would use either the back of his palm or his singlet to wipe off the sweat dripping from his body. He took little sips of water at certain intervals to quench his thirst and clear the road for the loads of rice lumps he was feeding himself with. It was between these bouts of heavy feeding that someone mentioned from the lower floor of the hostel that a call was awaiting Atule. Students on campus shared one phone which was secured to a booth. Atule quickly rushed down in his singlet. While hasting down, Atule wondered who might have interrupted his enjoyable meal. Nonetheless, he sensed that, the beeps from the machine (phone booth) could cause his early vacation from the good meal.

"Is she the one calling?" Mark Niendoo teased. This was a stout fellow who usually tease anybody who entered the phone

booth about the possibility of the person having spoken to a lover.

Asides letters, the phone booth was the next reliable communicative means in these times especially for young lovers. This made it a treasure.

Atule grasped the hand set that dangled and placed it on his ear.

"You are needed at home." said the voice said from the other end. There was no greeting. It was Assibi, Atule's uncle who works at a town council.

"But please." Atule was trying to probe further. The line went blank from the other end.

Everything within him and around him seems to have changed. His mouth suddenly became dull as though he was not the one that consumed the meal with an artistic style.

"What is it?" inquired Phillip Alunga, third year student.

"Nothing really. I'm fine." Atule answered and left like an individual whose cheque has been bounced. He made a swift turn and collided with Asam who had also come to make a call.

"But your sandals!" came the chorus from all by-standers. Atule tapped his head with his palm and shook his head. "What is wrong with me?" he thought. Intuitively, he knew that something was wrong. All bystanders knew that something was wrong. "But what could it be?" he asked. Calls such as these are not always good-sounding. Atule remembered his father's

observation that brisk speaking in parables among Africans foreshadows unpleasant information. A westerner speaks more directly with no parables to hide what must be borne. A true African boy would befriend a victim he wants to kill before dealing his deadly blow. Contrastingly, a westerner will just say,"Am gonna blow your fuckin ass!"

Atule's father has been suffering a severe bout of swollen feet which had started when even Atule himself was not born. This had necessitated the need for Atule to remit some amount of money from his monthly students' allowance home for the purchase of antibiotics. Atule began wondering about his father's condition after he got back to the room. "Is father seriously ill this time round?" he quizzed. He swung his leg and kicked whatever came his way.

"Are you Ok?" Apam asked when he chanced on Atule in this disturbed mood.

"I am going home to come", he told his roommate while folding two pairs of trousers and two shirts into a small bag be had bought at the Bawku market some weeks earlier.

"Is anything the matter at home?" asked Apam.

"Hmm, I don't know. I just have to go. I will be back soon."

Atule informed and sought permission from his hostel prefect and departed. He would almost be late if he

procrastinated a little. He has to rush in order to catch up with the last lorry bound for Zebilla else he would have to board a Bolgatanga bound vehicle which meant he will pay more. Atule had made provision financially for extra cost through a loan of Twenty cedis he acquired from Apam. Born and bred in Africa, Apam knew that some of these calls could have negative undertones and so was all out to render whatever assistance he had to offer.

Atule walked briskly. He hit his left leg against a stone. "Why?" he thought, "does this mean bad luck or good luck." In Africa, hitting the left leg against a stone portends evil. However, if it is the right leg, good omen is predicted. Atule was fortunate to have caught up with the last bus. The driver was a funny old fellow. He joked about everything from mad men to the likelihood of impotence in politicians who could not carry out their promises. By dusk, the vehicle arrived at Zebilla. Atule has to now reach his village on foot- two and half kilometres away. After walking 200 meters, Atule met Atibil, a fellow folk from the village, who decided to give him a lift on his motor bike.

"Are you just arriving for the -?" Atibil started and stopped.

"For the what?" inquired Atule.

Atibil then realized suddenly that he was breaking tradition by giving away a cue to Atule."Anyway, I am almost home." An inner voice was speaking to Atule. "What must be borne must be

do. Formal education cannot and must not turn me into a child when I am in fact two and half decades old" reflected, Atule. It was while he was lost in these thoughts that Atibil tabbed his lab, "We are home."

The sound of the griot's instrument - gonge - immersed the whole of Atule's usually quiet home. Men in "fuugu" darted here and there chatting drunkenly and busy about nothing. The log seats outside the house were filled with many people. As Atule drew close to the house from Atibil's motor bike, he felt the pressure in his throat. His legs suddenly became heavy, almost hesitant to draw closer. The cold evening breeze blew over his body as if to welcome him to the celebratory mood of the home. But it was a forbidden joy for him. As if shocks never end, Atule realized when he finally got to the yard that the village petty traders had relocated to his father's compound. Sweets, bread, cigarette, alcohol, and local beverages were all on display. Some of the women traders were busy about frying local cakes-koose and mahsa.

Someone wrestled Atule bag and took it into the house but he did not know who it was. Anyway, that did not matter to him. "But who might be dead?" he mused to himself. He was in the midst of this thought that his uncle demanded his presence. Uncle Anyaan tabbed the wood log the others were sitting on and beckoned Atule to sit down.

"You are welcomed my son" Uncle Anyaan said.

Atule got up from his seat, stooped low, and shook the hands of all the elders at the "zaa-yoor" (Court yard). Respect for the elderly is considered highly amongst the Kusasi and other tribes in Africa. Procedural greetings that go in tandem with customs is a way of displaying honour towards the elderly. He was asked to sit and listen to the reason for the call he got earlier in the day.

"How is your work place?" asked Anyaan.

"There is peace. How about here?" returned Atule. Anyaan did not respond.

"We thank God your work place is peaceful. We hope all your friends and colleagues are doing well."

"They are all well and eating."

"We also slept well yesterday. The cold has been severe over us every morning for sometime now. Thankfully our log woods have been helpful in keeping us warm. Even so, we left their comfort this morning when your mother called," he paused to take a bite of kola, chewed it for a while and continue, "so Amaltis sent for me when I hadn't even washed my face. Because her call came too early, I sent your younger brother, Mbabilla, to alert Abugri my brother. We almost outdid each other in a rat chase to get here. Your father, I mean my elder brother, Mba, had not yet seen the sun's light when we got here. I was surprised. Only then did I realized that his leg might had held him down. But I prayed earnestly that it wasn't the case…"

but then there was a sharp, vehement yell induced by overly indulged liquor from some few metres away. The owner of the yell muttered something about he having no reliable source of the best tobacco to buy again. He was shut up by a stern voice which warned him, with equal vehemence, of the potential beating he will deserve if he kept whining about nonentities when real men were about serious business. The yelling voice ceased instantly. Mba had sold tobacco to neighbours and his brand was recognized as the best in the village though he never really made it his sole preoccupation.

Anyaan proceeded with his impartation when the intruder had been silenced. "My brother's condition looked desperate so I consulted a 'baagre' which revealed that my brother's soul was tired of dancing in the yard. He now wanted to go indoors for a rest .We did the necessary rites to facilitate his journey and he did so before the last dew fell off plants this morning. Your father already made available two bottles of gunpowder but you will need to add more. He was a great man. We must celebrate him."Anyaan concluded his mission and gathered the flaps of his 'fuugu' between his laps, took another bite of kola, and adjusted himself on the log seat. Atule just stared down speechless. Tears flowed from his eyes. The lines of T.B Yetes came rushing through his mind:

> *'Turning and turning in the widening gyre,*
>
> *The falcon cannot hear the falconer,*

Things fall apart
The centre cannot hold
Mere anarchy is loose upon the face of the earth.'

As these lines rushed through his mind, Atule became lost in thought. He has become an orphan. He has little siblings to care for. He has yet to marry though his age group had married and borne one or two children. And above all he was still a student when his fatherlessness occurred. Will his people understand if he is unable to shoulder the responsibility that comes with being a first child? Many of Atule's family members were illiterates who saw anyone who made it to the post-secondary level as one who should be well off. Atule was always referred to as doctor by the family though he was a nurse trainee. This misconception was not peculiar to his people only. Other people elsewhere in Africa defined western education along similar lines.

Anyaan, Atule's uncle, was also a witty old fellow with a weird character. He and Mba would always argue over trivial issues. Anyaan will renege on his responsibilities to the larger family but will want to claim the glory for every success the family chalks. Mba never hesitated sacrificing his belongings like animals and food stuff to resolve the larger family's difficulties. Contrastingly, Anyaan will never do same though he is always ready at hand with giggle like a jackal to consume any liquor or meat obtained when the family's issues are resolved

and such goodies are available. This uncle could not be relied on. Atule thanked his stars that he had even borrowed enough before setting out from school. At least he will have something to rely on if some little expenditure was expected. When Atule's cogitation ended, Ataama's soft touch reached his shoulder to provide comfort. Ataama was Atule's elder sister. "Our father said we should remain united. Though I don't have so much money, I will support you in whatever small way I can" Atama said. "Go back to where women belong," cautioned Anyaan.

Atule headed for the inner compound to see the mortal remains of his father, Mba. He knew that the corpse had already been given the first bath, a landmark bath done before relations elsewhere, in-laws, and neighbors are informed. As Atule walked into the inner yard, the sound of local guns in four successive order were heard. Atule dipped his hand into his packet and gave out Two Ghana Cedis for the purchase of gunpowder and some drink for the grave diggers. Akoom, a good local violin player spotted Atule and started eulogizing his late father and the greatness of their lineage. In Kusaug tradtion, such praise singing from these griots is rewarded with money at funeral grounds. Atuule did some few rounds of traditional dance and placed two notes of Two Ghana Cedis on the violin player's head before he was given good passage to look at his father. The women in the yard met Atule with high pitched cries which incongruity gave the picture of choristers who have missed their lines but trying desperately to catch up with their instrumentalist. Atule headed for the room, took a look at his

father, and hugged his mother-an unfamiliar behavior among this people. Amaltis eulogized her late husband in the presence of her son amidst sobs. A woman must sing the glory of her deceased husband even if there was some bad blood between them. After all is he not the father of her children? Atule gave his mother little taps at the back and consoled her to hope for a better tomorrow despite the sorrow of today. "All is not lost" he said, "we will live in greater unity and care for you as he did" Atule added. Despite the high emotions that greeted him in the room where his father's remains lay, Atule held himself together as expected of first sons in this culture. Manliness entailed a capacity to endure pain (devoid of shedding tears) even if emotionally depressed. Atule tried his best not to cry. Shedding tears is a feminine trademark used to mourn the dead. "Men" it is said, "do not cry."Atule's face looked as if he was struggling to discharge constipated stool. He was successful in consoling the poor old woman. She was comforted, at least. For who will not be when a potentially responsible son consoles her at the bier of her husband. Amaltis hissed whilst wiping her face with the end of her cloth.

Arrow of Success | Azurago Jonas Anafo

Picture of the Funeral ground

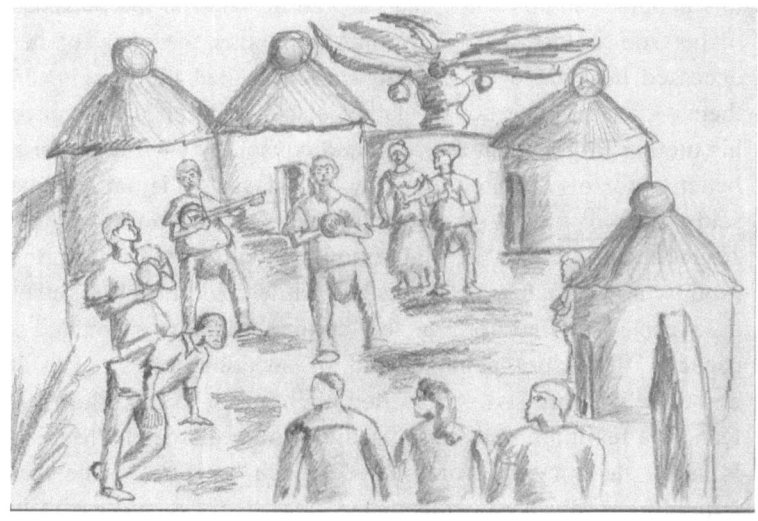

CHAPTER TWO

THE BURIAL

The burial of Mba was no small matter. For a man of his calibre only the best was fit for him. He was a hardworking man, a responsible family man, a good elder whose counsel the chief valued and a man who loved his larger family. To cap it all, he, among all the men in this part, had succeeded in putting his son into the 'Doctors' school at Bawku. Mba had mounted and rode his own horse in life. Even before his father died, Mba had built his own home with the gains he made from working on cocoa farms in Nzema land in the southwest of the country in the 1950s. He also made wealth rearing goats and sheep initially and later cattle. His farms were meant not just to feed himself and his family but to gain enough for sale. His wife was an expert producer of shea-butter which brought her substantial income and made her financially better off than most of her peers. This was the secret to her ability to push her children through school when many women could not do so. Mba's home was simply well-off compared to most of his neighbours. His younger brothers, Anyaan and Babuni, remained in the house built by their father. Only Abugri, his other brother from another woman, had also left. Abugri's house was a short distance from the home of Mba. Mba's house was made up of four compounds. Each compound was separated from the other by a short wall. Mba's abode was at the entrance of the house. It is so in Kusasi culture

because the head of a home must protect his dependents by confronting danger when it threatens. The practice has trickled down to the modern era with the over reliance on masculine protection for women and children. Mba was one of such worthy men who gave the utmost protection to those under his watch.

Mba's mother was a great woman who was partly responsible for his outstanding upbringing. Mma Ayamma herself had been the first child of her parents trained with a flair for independent action. This helped her a lot in her marital home where she was one of three women competing for the attention of her husband. According to many individuals, Mma Ayamma was an epitome of womanhood. A woman so described in Kusasi tradition is one who has birthed many children and groomed them to be responsible. Mba therefore benefited from her mother's rigid training of her children though Anyaan was the only child of Mma Anyaama who, from childhood, vowed not to follow such convention of his mother.

Atule only grew up to learn that his grandmother was an outstanding woman who birthed many children- four boys and five girls. All the girls were married. They have all returned to see their brother off as 'doog dim,' litearally caretakers of the room. The four barns in front of the compound had logs of woods lying by them which acted as sitting places for the vast majority. These barns,'bo-ot,'serve as silos for the storage of food stuffs such as millet, maize and other food stuff. It was against these silos that in-laws leaned while waiting for the word

for the digging of the grave. The in-laws had arrived in small parties from five different communities. The concern for Mba was seen in the number of people who had gathered. After the family oracle was given a round of libation, the way was laid for the digging of the grave. Anyaan squatted. He was the one to do the measurement for the grave. He took a calabash, "wan ," lifted it toward heaven and placed it on the ground at a portion designated for that purpose. "Spirits of our ancestors, accept this noble offering and grave soft ground for the 'hiding' of your son, Mba' muttered Anyaan. As the first son, Mba was to be buried outside the house. Luckily, it was a dry season and there was thus no need to destroy any crop to pave way for the digging of the grave. Anyaan used a small hoe –'kusie' to scrub the exact width of the calabash and afterwards destroyed the calabash.

All had been set and digging commenced. About three (3) violinists spurred the diggers on through eulogies and all kind of songs. Amongst them was a renowned violinist, Anaaf Kuguut. He had a classic voice. Atule and all who had gathered there would occasionally get glued to the tunes of the violinist, make some local dance moves with the 'fuugu' they wore, though they were mourning. Two gallons of 'pito,' a local beverage drink brewed from local malt was distributed in calabashes. Having gained more knowledge about communicable disease, Atule watched how his people carefully enacted the culture of love through sharing though health implications abound with such sharing of drinks from one calabash among two or three people.

He also thought of the similarity of this practice to the culture of kissing in telenovelas. Atule then cogitated on how he can redirect the way his people express their culture of love through sharing. Whilst in a state of thinking, Anaaf kuguut, the violinist, came near him and started to eulogize the man who gave birth to Atule. Anaaf described Mba as living the life of Asuul, the invincible wise rabbit in Kusasi folk tales. Mba's wisdom had earned him this accolade in the community. Atuule parted with a cedis on that occasion. Energetic young men dug the grave up to about two feet using a spear-like object with a wooden handle. It was now time to widen it from that point in time.

Picture of a grave yard

Siddiq's Art

Whilst all this was happening, the women stayed in the room keeping watch over the corpse as custom demanded. The practice was rather ironical and repetitive. Just as a mother takes care of a child after birth, so are women tasked to care for corpses before they are laid to rest in the bowels of the earth.

While the digging continued, calabash-filled rounds of 'zomkoum,' a local drink of flour mixed with sheabutter went round the digging site to refresh the diggers. A fowl, 'yoognoa,' and goat, 'yoogkobiig,'was offered to the grave diggers. They were killed and cooked, awaiting consumption by the diggers after the body has been laid in to rest. This, for Atule, was not different from the slaughtering of animals for food preparation at Christian funerals. When the widening of the grave was complete, all the diggers knew their work was almost complete. The leader of the diggers, and a member of the larger family of Atule, Ndeobba approached the elders sitting at the house' entrance, 'Zaanyot,' stooped low, and declared the grave ready for concealing the remains of Mba. A group of about five elders walked to the grave and did thorough inspection of it. Each person voiced his opinion of what he thinks must be done to give the grave a perfect finish. The diggers resumed work to put those finishing touches to the grave and ensured it was finally ready. When the approval of the elders was pronounced, the diggers parted each other for a work well done and stretched themselves on the mounds of earth they had thrown about awaiting the arrival of the corpse from inside the house.

All the elders moved inside the house and into the holding room. Children of Mba and all close relatives gathered at the bath room, 'taansoog,' to give Mba his final bathe. He was kept on the laps of his daughter in-law, Adelsum. Anyaaan, who performed the ceremony, asked for dirty water, 'koombeeti' - a mixture of hot water and herbs- to bath his late brother. Women let out their voice in wails and cried their hearts out. Though the men sought to quiet them with warnings, the women persisted in their wails. A combination of the perfume and powder used on the corpse gave the atmosphere an improved air. The profuse sweat that emanated from the pores of the handlers of the corpse depicted the heat of the harmattan. The absence of windows compounded the ventilation difficulty in the room.

Abugri, a younger brother of Mba, had brought in the goat skin which was to be used for the clothing of Mba. As the process was on going Atamba, another younger brother of the deceased, was drunkenly protesting the burial of his brother. "Mba can't be buried now! I won't take it!" he let out. But his weak body, caused by the strong liquor he had consumed, was held down by four unknown arms. He was held because he nearly fell on his late brother in this drunkenly mood. All the people around rebuked Atamba and asked that he should be carried out of the holding room. The Kusasi people take custom seriously just as other African cultures do. The dead are given the greatest of respect. The body of the dead is usually buried early to prevent it 'spoiling' which means decaying. Decayed

human bodies are sacrileges in Kusasi custom. This explains the refusal to bank the dead in the morgue in the light of modernity among this people. However, some people will not to be put in at the morgue when they die.

Atule was called to do some rites on behalf of the children. He bent low, held 'mus' (elephant grass) with which he swept his father's body trice into a pot containing roots saying, "My father, when you were alive, you had something which helped us all. It looked after our lives. You may perhaps take it away so I am sweeping it." All gathered nodded their heads in agreement. They probably seem to be endorsing the action of Atule. Three cowries were placed on the goat skin which had its tail facing the room's entrance. This will be used to wrap the corpse. Other clans in the Kusasi traditional area would usually use different kinds of animal skins thus antelope, deer and so on. In the days of old when there were lots of forest, clans would go and hunt for such animals whose skin would be used for the desired purpose. However, as the natural forest has gradually degraded, people would usually purchase the skin of these wild animals from the market and hang them on the walls of the medicine room, 'zoong,' in advance.

A goat was killed outside the house for the children of the deceased to take a communal meal together. It was cooked outside the compound. Atule was not particularly interested in that. He however went out and picked a small piece of meat and tasted it in accordance with custom. He was happy the funeral

rites were gradually coming to an end. "What a humiliation,"Atule thought to himself, "if my father was kept in a local mat 'soungu', foldered, and tied.'' The corpse was covered in the goatskin Abugri had brought. The corpse was taken and moved outside. The dead man's son-in-laws, who were readily dressed in their 'fuugu,' received the corpse and carried it round the compound house three times. At the grave, a senior sexton went down the passage into the grave before receiving the lowered body. It passed through the grave's entrance which was created using the circumference of a calabash as measurement. The sexton then positioned the body in the proper laying position. Mba was old so he was laid on his side. Pieces of rocky stones were used to cover the corner where the corpse lay. Once out, the sexton ensured other flaky stones were used to cover the main entrance and then crowned with a pot. Holes are bored through the pot as a passage way for the soul of the dead who must sometimes commune or dine on the sacrifices of the living. It is through such holes that the spirits of the dead visit the living. The dug out earth were then conveyed to cover the grave. As the eldest son, Atule was made to take an active part in the whole proceeding. He was assisted in the whole process by the sextons because the act of being a sexton is secret which demand that the uninitiated are given great guidance when they are to partake in it at a single occasion like Atule's case. When the whole party returned from the burial, Atule climbed to the top of the 'holding room' called 'zong' and let out a great wail to draw attention. Holding a fowl 'o buanug,'

he eulogized his father and threw a challenge to any who has achieved such feat to come forth and wrestle the fowl from him and slaughter it. No one came. He slaughtered the fowl and drew it on the refuse dump 'tampuut.' Varieties of wails, sobs, cries, and screams were ever coming from the womenfolk who had kept to the safety of the inner yard throughout the burial itself. The fowl Atule killed will lie there for two days and won't be picked up by anyone. Atule had certain reservations about the manner of burial his father's remains went through but dare not complain.

Picture of the hold created at the holding room where Mba's body would be passed through

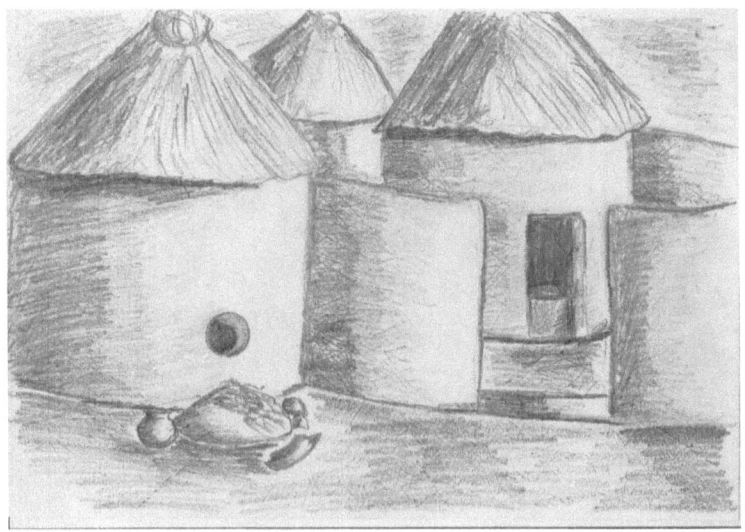

Siddiq's Art

Picture of corpse brought out of zong and carried round

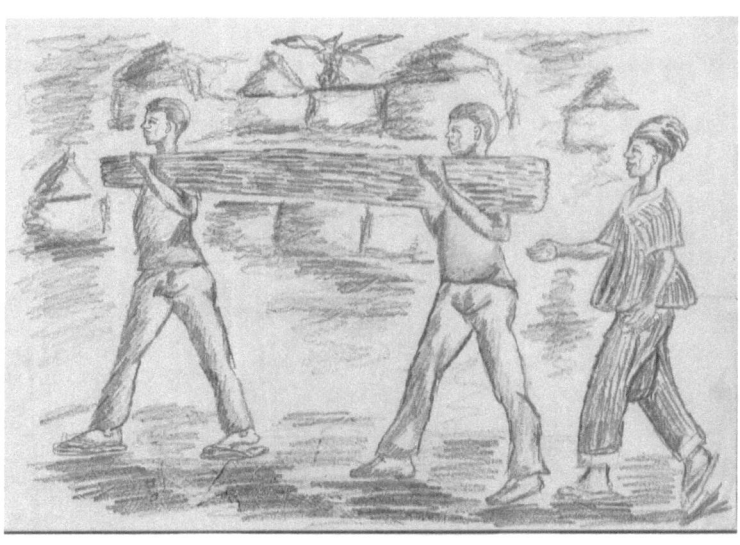

Siddiq's Art

Though Atule was sad for not completing his study before his father's death, he was somewhat happy his funeral rite was given some traditional standards. However, he had his own misgivings. But is that not that same man you all abandoned when it was critical? Atule asked introspectively. Is it because of his little property that my uncle, Anyaan is so curious to see him put rapidly into the grave? Atule was certain that his father had left some reasonable number of cattle, sheep and goats. However, he did not know where majority of them were.

When the last lap of earth was thrown on the grave, the procession of elders, male family members of the deceased, and the sextons did the last sacrificial rites and returned to the outer courtyard where a special herbal mixture had been prepared for the cleansing of the sextons and those who had gone to witness or actually undertake the burial of the deceased. Guns were then fired. The firing of guns continued as the elders went back to the outer courtyard. People quickly regrouped into herds of chatting parties some of who were drunken chats. Once the burial was done, people who had effectively restrained themselves from joining the booze party could no more honour their self-imposed vows of drunken celibacy. Eyes that had hardly noticed some people began to stare long at everything and recognized nothing. Solid bodies that had torn open the earth to lay Mba suddenly became swaying bodies controlled only by the wind and the urge

not to fall though that didn't help others. Chats became more gregarious and loud. Everybody shouted to the other in the name of chatting like lost hunters who hope to attract the attention of any good Samaritan increasing the pitch of their voice. The outer compound of the late Mba was the embodiment of noise gone mad. Grown-up men, under the anointing of strong liquor, cried like day old babies as their widow's mite to the mourning of Mba. They had shut the women up earlier, now they couldn't shut themselves up though the women had had genuine reasons to cry than they do. While they cried to honour their ecstasy, the women had cried to honour Mba's great life. Such is the irony of action embodied in the genders. There was merry everywhere. As the night wore on, the moving and swaying bodies dropped off one by one on the large outer courtyard to take their day's retirement till morning. The women and children of the inner compound gradually lost the energy to continue the tireless enterprise of mourning a man who couldn't be brought back. The harmmattan blew its tantalizing breeze over the small village and everybody drew ever closer to every mat or skin under them.

It was like just a moment. Atule woke up to the snoring of sleepy souls all around. The last night had been a particularly tiring one. He had fallen off to sleep without even knowing it. At times like this one owned no room except the outer courtyard. Suddenly, the reality of the day before dawned on him. His father was no more. "Who will I fall on in times of needs?" he

silently quarried himself. "Be each other's keepers," Mba had said in his final minutes to his children. Atule was reflecting on the events that led to the gathering of many people at their home. His meditation was short lived because many of the people were gradually waking up from their sleep. They had slept on fibre mats, "soungu". Some lay on log woods. Those who had been floored by alcohol were now waking themselves up albeit slowly and twistingly like snakes. Most of the elders slept on goat skins, 'gbang.' All over the compound people were waking up to the morning. Calabash full of water was being requested by everybody and young women were busy distributing them. The men will sip the water, rinse their mouths, and then spit it out. They will rinse their mouths several times rubbing their fingers against their teeth as they rinse. This is followed by the chewing of sticks from nim or other trees. This practice was common to most African tribes prior to the introduction of the toothbrush and the toothpaste. He then jumped and broke a piece of stick from a nearby nim tree which is used to further cleanse the mouth. For some who can afford, buying well-polished sticks at the market is another way of acquiring these sticks. Ntoya, a young man from Agatusi who was in-charge of firing the guns, loaded some rounds of gun powder with some of his assistants and reminded the whole of Teshie and beyond that Mba had died the day before. This sent the wrong message to the children in the house. They started shivering, crying and clung desperately on to their mothers in the compound. Their night has been peaceful until Ntoya

spurred his nonsense to scare them. The swaying souls of yesterday suddenly came to life. Someone was muttering, this time with coherence, about the wickedness of this thing called death and how he has been bereaved of a great source of good tobacco. It was then that Atule realized it was Atangkolgo, a great lover of Mba's tobacco and a good onion farmer.

CHAPTER THREE

THE FINAL FUNERAL RITES (DRY FUNERAL)

The burial of Mba had been successful. The expectations of all around had been met. Two days after, Atule decided that it was time to go back to school. Fortunately, this day was a market day in Zebilla. Many had dispersed but a remnant remained to empty the last bottles of liquor. Anyaan, the next in line of authority after Mba, was all gay this day. His ecstasies aroused concerned suspicions among some of the close-knit family group especially Atule. His utterances had an air of dominance now that Mba, the sole authority who ranked higher than him among his father's, children was gone. This perplexed Atule a great deal. Naba Atampugre, the patriarchal head of the Ataa-biis clan to which the family belonged, had quite seen nothing wrong with Anyaan's behaviour throughout the third day rites. "Was it a silent approval of an irresponsible uncle's attitude?" Atule asked himself.

Atule slept off again after the dawn rites to mark the third day after the burial of his father. A tab at his shoulder woke him up. Before him was 'sagbo,' a local meal of stirred flour, served with soup prepared of 'bito,' kenef leaves. The 'sagbo' was served in an earthenware bowl and smeared with shea-butter. This gave the dish a sparkle which could not fail to wet one's appetite. Atule took a sip of water from a calabash, rinsed his

mouth, and spat the water out. Accidentally the travelling water splash unto a passer-by's feet. Atamba was ready to reprimand the offender when he realized it was Atule."Oh, doctor, are you now eating? Carry on. I have had so much of it already" Atamba said. Atule was thoroughly sorry. He realized he shouldn't have done that. It is more characteristic of illiterates but not well educated people like himself. However, it is not easy to detach one's self from certain behavioral patterns because they can be recessive. But behaving differently may also attract rebuke from those who see nothing wrong with such practices.

"Is my father, Anyaan, around? Atule asked Atamba.

"Yes, I saw him near your father's 'zon'g.' Atamba answered and went off.

Atule was going to inform Anyaan of his intention of going back to school that day. "After the meal, I will approach him." When the meal was effectively done with, Atule lifted his now heavy body and rolled leisurely towards the house and to the entrance of the inner courtyard where his father's 'zon'g' stood. There Anyaan was. He was comfortably resting in his late brother's quarters.

"Excuse!"Atule alerted.

"Yes, come in." Anyaan responded.

Atule duly informed his uncle of his intention to return to school now that his father has been buried. Anyaan did not sit up. "Ok.

You may go" was the response from him and went back to rest. Atule felt like bursting himself open but instead walked out. Amaltis met Atule just as he came out and sensed something wrong with him.

"What is wrong?" she inquired.

"I just told my uncle that I am returning to school." Atule responded.

"And what did he say?"

"Nothing".

Amaltis held her chin in disbelief and the tears flowed down her cheeks. For a woman who had lost a husband less than a week, this seemed too much for her. She untied the knotted end of her cloth, brought out notes of money, and handed forty cedis (Ghc40) to Atule. Atule's earlier frown gave way to a smile of triumph. Mba had had an old bicycle. Atule brought it out as a means to transport himself and his sister to the Zebilla market. She will then return with the bicycle. In this part of the land, motor bicycles and vehicles were expensive means of communication during this time. Contrastingly, donkey carts and bicycles were cheaper means of movement. Atule took time to greet most of his maternal and paternal relations who had remained of the mourners before setting out to school.

As Atule and his younger sister were about setting out, Anyaan appeared at the entrance to the inner courtyard with his

hands crossed behind him. He instructed Assibi, the younger sister escorting Atule, to return early and perform some few tasks. However, if his younger sister was to return for another errand then who was to send the cattle out for grazing for the day? Assibi looked visibly worried and unhappy about the change of routine her uncle was trying impose on her. Atule however urged his elder sister to forget all that had transpired. Atule was fortunate to arrive in Zebilla in time for the next vehicle to Bawku. There was a lanky fellow bellowing his heart out to attract passengers to the vehicle. Atule booked a seat and quickly paid the cost. Though he had booked a convenient place, the front seat, he prayed an elderly person or a person with traditional authority will not board this vehicle because he will be compelled to sacrifice his seat for such a person. As a nurse though, most individuals accorded him respect and it was quite evident at the station as he was popularly referred to as 'doctor'. It was actually discomforting if one sat at the back part of the old Peugeot pick-up which had been converted into a passenger car. Passengers sat in two rolls on benches facing each other. One had to bend to climb unto the vehicle. This upright sitting position played to the advantage of short individuals over taller ones.

When the vehicle was full, the driver took off. Atule was very happy because he could at last get back to school and catch up with academic work. The vehicle passed the towns of Yikurugu, Saka, and Kobore. The road was like an endless

brown snake with little spots which the driver had to navigate around. These pot-holes made smooth driving difficult. Even in a part of the country with huge potential for onion and cereal production, the roads remained undone. His eyes spotted the trees on the banks of the White Volta, a river that separates the Bawku East and West Districts. Atule was thinking about the beauty of nature displayed by the White Volta. Atule's grandparents had also planted a great garden that became famous for the variety for its fora holdings in this part of the country. "Gradpa and Ma were really visionary people. How could they have seen the necessity of bringing cocoa, plantain, palm nut and other forest agro commodities to the savannah in those days of old? Those two old folks were really wise and great people"-he (Atule) thought. Though Atule did not meet his grandfather, Akolba, he had heard a lot about what he did. The old man used to travel to Kumasi from where he brought home cocoa, palm trees, cocoa yam and other seedlings, which he and his wife planted in their garden at the village, Teshie. Atule learnt more about his grandparents' efforts which helped put the village on the national stage as an interesting and intriguing agriculture community. He therefore saw his grandfather as great community figure, a Tetteh Quarshie of the community. He dozed off through these moments of meditation and his body, paying up the arrears of sleep he owed mother nature, danced to every curve and bend the vehicle made. A fellow passenger in hurry tapped him. He came to life and

realized he must make way for this fellow to alight because the journey had come to an end. The lorry had arrived in Bawku.

The legs that carried Atule to his premises seemed to have sped off more quickly than Quick silver. Atule drew the curtain which partitioned the door to their room and to his bed. It was time to rest, he thought. He went straight for his bed and lay in a recumbent position but with his legs on the floor and head supported by a pillow.

"You are welcome back," his roommate, Apam, welcomed. "Sorry, we heard of your situation- accept my condolence. Good morning" he continued.

"Thank you very much" Atule said.

"Do try and take something. I brought you breakfast. You have run down so soon" Apam pronounced.

Atule listened and poured himself a good cup of porridge which he took with bread. Afterwards, he attempted to rinse the cup but spilled the water. He poured another round of water and, holding the cup with his right hand, took a good sip of the mixture of some little porridge and water and then relaxed. Apam excused Atule to attend some lectures. After he left, Atule look a mirror to assess himself. He thought conclusively that Apam was right. "My eyes are deep and the region between my scapular and color bone are depressed" he was telling himself. It is what is described in the local parlance as hunger bowls,

"komsaalaas.""Oh God, save me!" he exclaimed. He took another cup of porridge and tried to consume it but his appetite had left him.

After the day's lectures were over, majority of Atule's mates trooped to his room to offer him their sympathies and solidarity, a common African practice which shows the individuals enjoy in moments of grief. Examinations were near. Such sympathies were a great boost to the morale of Atule though he was undoubtedly a bright chap. Apam joined his colleagues as they walked down the stairs to fetch their pounds of 'sagibo' and dry kanef leaves soup that awaited them at the dining hall. He carried along Atule's bowl. The sympathies for Atule had not been in words only. In Africa, one must express sympathy not just in words but also in actions. His colleagues were giving him the best attention as possible so that he can recover from the shock of losing his father.

Atule had decided that he must let his father rest in peace. The elders say, "a man cannot cry over spilled milk." Nothing can return his father to earth. He was cogitating over this when his mates returned from the dining hall.

"Atule what is the matter?" Niendoo asked.

"Oh no I was …" he responded.

"I understand you. It is not easy. But give praise to God in all things" Niendoo admonished.

"Anyway, what did you learn in class today?" asked Atule.

"You must be tired and need to rest" Apam interrupted.

"Just a gist" Atule begged.

"Ok. I will give you some gist" replied Niendoo,"we treated medicine, surgery and obstetrics."

"Oh ,obstetrics. I hope the obstetrics Madam was not boring as usual?" Atule asked. Apam continued narrating the details of what they were taught. Atule listened keenly as if he was in a lecture hall. He then asked questions that were necessary to seek clarifications. Atule spent less time on his books, thanks to this method of learning, which he practiced religiously. Some colleagues who knew his background sought to link his intelligence to a strong spiritual base in his family. Atule detested such crude thinking. His academic exploits had gained for him the nick name Socrates.

The Funeral Preparation

Months passed. Atule had completed his course of study and took the two month leave period given him to rest and prepare for his permanent posting by the Ministry of Health. During this period, he mooted the idea of taking steps to perform the customary funeral rites of his father. This was especially taken seriously because it marked the customary separation between the deceased and his earthly relations. But this time was the harvest. People were busy harvesting their late millet. The year brought with it bumper harvest. Then the harmattan winds will blow with fierce force and with great cold that will keep people indoors like westerners escaping from snow and the winter. Drops of dew dropped from millet his mother had planted. Amaltis could no more partake in other feminine activities like going to the market because of her mourning rope. She must wear this till her husband's customary funeral rites are done. The restriction enabled her to fit into the void left by Mba. That explained the prospering of the millet and animals in the home after Mba's demise. Atule detested those sartorial markings on his mother anytime he saw her and wished them off her. This was the other motivation for wanting to get the funeral done. These ropes made of jute, are usually taken off the widow's neck during the performance of her husband's funeral. Until the funeral of a woman's husband is performed, she is not supposed to have sexual intercourse with another man. A

contravention of this rule invites certain rites to be performed. It involved making her pass through a hole created on one of the walls at the back of the house. Though the contravention will be forgiven with this rite, the woman and her children live with this humiliation all their lives. Atule was sure his mother will not stoop low to that. The dignity of the children was therefore assured.

One day after a hard day's work, Atule was summoned by an elder family uncle. He asked Atule to come over after supper. Atule did.

"My son, God has blessed us this year. I can see that your father's barn is filled although the harvest is yet to be completed. You 'karakyis' have your farms in books". "You know very well that your father's spirit needs to have a peaceful rest. Go and think about it", he added.

The Kusasi, like most of their African ilk, do not speak in plain and direct language when meaning can be established through inferences. Atule immediately read meaning into what he said. Atule discussed the issue late into the night with his mother. They both resolved that he should return and speak to this elder uncle the next day so they fix a day for the final funeral rite of Mba. Atule decided to bring the animals he had with his uncles at Binaba as extra support for the funeral. Amongst the Kusasi people, it is believed that a man is supposed

to have a secret place where he rears his animals as security against any rainy day.

It was a cloudy day in November and Atule was resting under a mango tree. He was absorbed in some thoughts. "Does it mean that that man Anyaan has decided to behave as though Mba is alive? Will he intentionally leave all the expenditure of the funeral on me?" he asked himself. "That explained his attitude the day I was leaving for school. Father was right when he said every individual protects himself when hailstones are falling from the sky" Atule reminiscences. He resolved to shoulder the responsibility for his father's funeral.

"Why are you so lost in thinking," Amaltis interrupted.

"Mother, we must perform your husband's funeral. But you know my younger uncle has confiscated all the animals my father singlehandedly raised with the support of Mallam Jalo Sidik at the Tilli forest. What animals will be used to give my father a befitting funeral?" Atule complained.

"Hmmm. That's not all. Whilst you were in school, Anyaan will drink to the brim, invade this house, and rain insults on me" his mother added. "But for the timely intervention of my family, I would have committed suicide" she buttressed.

"Yet he pretended to have loved his brother when he was alive" Atule said. "He was simply a sheep in wolf's clothing. His target was father's wealth" Atule concluded.

In most societies in the Africa, some individuals pretend to show love to their sick relatives with an eye on the person's wealth. They will wail and sympathize with such people as though they are prepared to bear their sorrow. It has become a global problem where individuals within families are not always content with what a relative leaves for them in his or her will.

It was Agatusi Market day when Atule decided to inform his immediate family with his decision to perform his father's funeral. The venue was the outer courtyard of Anyaan's home. As custom demand, Atule squatted and offered his greetings to the elders who were seated from the right to the left in order of age. The Kusasi hold greeting in high esteem and consider it a key mark of respect and honour. Speaking through a middle man, Anyaan asked Atule his mission. During such functions, the elders will hardly address the speaker directly. Atule replied that a hunter does not wait on an antelope to die slowly when he deals it a blow but must finish off what he begins as quickly as possible. He made it clear then that he and his mother and siblings wish to send their father home customarily early in the coming year. The whole place became silent. The elders whispered into each other's ears. It must have come as a surprise to them. Atamba, the most efficient drunk of Atule's uncles, gave a wide grin at Atule to assure him of his approval. But such approval from Atamba meant one had to part with the cost of a bottle of liquor. No objection was raised because the one to do so will later be expected to shoulder a little of the responsibility

for the funeral. It was concluded that the funeral should commence the first market day of Teshie in the New Year. Messages were to be sent to neighbors, in-laws and family relatives far and near.

CHAPTER FOUR

UNROOFING THE GRAVE

Atule sat on a log of wood placed against a baobab tree in the outer courtyard of the house. It was a Tanga market day evening. In a week the funeral celebrations of his father will end in three days. Everything had been prepared for the event. He will travel to Binaba to walk the animals for the celebrations from his mother's brother. All the necessary requirements and things for the funeral have been fulfilled or acquired. While he was thinking Azuut, a community drunk, was passing by. He called Atule by name and asked if he had prepared enough for the funeral because he, Azuut, and his best of best friends were preparing to come and give Atule a great celebration. Atule gazed at him sullenly. "Does he think that I am not a man enough?" Atule thought. There Azuut went like a ruffian bird beaten by rain, a helpless creature indeed. Among the Kusasi people, ability is usually measured in muscular terms but Atule took a different view about ability. Atule resumed his mental calculations and planning once Azuut had gone away with his distraction.

It was three days to the commencement of the late Mba's funeral when Atule decided to visit his uncle for the animals that will be used for the funeral. He woke up early and set off in the company of his cousin, Atubiga. For the local people, Binaba

was a faraway place. But the place was a seventeen kilometres distance from Atule's village. Atule chatted about his first visit to his uncle's home when he was sensible. His uncle had given him a fowl which he brought home and reared. About two years later when he was in primary four, his fowl had produced enough young ones which were sold by Amaltis, his mother. With the money, she had bought him a goat which he was fun of. The goat birthed many young ones too. But his father's constant habit of catching the little boy's goats to solve his problems compelled Amaltis to move all five goats to her brother at Binaba for safe keeping. Mba had grumbled about this but knew he was in the wrong. Later, Amaltis' brother sold many of the goats and bought a calf which grew healthy and productive too. Now in his mid-twenties, Atule owns five cows, several goats, and two sheep. He was picking out a cow and two goats to facilitate his father's funeral celebration. He now thanks Amaltis so much for her foresight which many women lack in the village. Atubiga also related his own experiences in his uncle's home and how it had become a second home for him. The conversation veered off to other topics including some teasing for childhood pranks played on each other and on others. All this while, the party of two had inched closer to their destination. By sun rise, the young men arrived in Binaba. The generous uncle who had raised the animals for Atule was at home when they arrived. He had got the animals ready. A bullock and two goats were tied against a tree.

After the customary greetings and feasting had been done, Atule and Atubiga chatted with some of their cousins for a while before departing. The two animals were untied and led away. Atule took on the bullock while Atubiga handled the goats. Fortunately for Atule, the bullock was not aggressive. Atubiga did not also have any problem handling the goats. The journey was smooth sailing for the men. At certain points in the journey, Atubiga offered that they switch animals but Atule declined. Atule thought any switch will make him inferior physically due to his education. Masculinity for the Kusasi means the capacity to go through pain, hardship, and difficulties without complaining or giving up. This view of masculinity is synonymous with the opinion held among many African people.

The Uncovering of the Grave

It was the first market day of Teshie in the New Year. The funeral of Atule's father began in earnest. The first sign was the firing of guns. None did that better than Ntoya in these parts. He mounted his equipment some few metres away from the outer courtyard. All he needed was set. He had ten pieces of metallic rod each with a tiny opening in them. Gun powder was kept in a small pot and a piece of metal rod was used to help compact the mixture. Other items were available namely sand which was placed on the gun powder to produce pressure for the gun fire. A piece of stock which would act as the trigger was also in place. Ntoya had a whole pot of 'da molga,' a local brew made of millet, to energize him when he needed to gulp down something refreshing. Ntoya undid the little smock he wore leaving a sleeveless shirt- one Atule knew him to have worn since he, Atule, was a child. This way the upper part of Ntoya's body was visible. His muscular hams and huge chest were impressive. This was symptomatic of a strong man. Children were gathered around the place to catch a glimpse of what was happening. It was always an atmosphere of fun and fear. Ntoya was a very jovial man. As the children stood watching, he would call one of them to come so as to be sent. When he graps such a kid, he would try to send him or her near the metallic objects just to scare them. He would then release them. The victims and other spectating kids will take off on their heels to the safety they

knew best and burst out laughing. It was fun and fear. The kids liked Ntoya very much because in addition to the fun, he would give them meat when it was available.

Atule watched Ntoya and the kids with nostalgia. He approached Ntoya.

"Good afternoon"Atule greeted.

"Oh, good afternoon my boy" Ntoya responded."I can see that you are very tired. But be strong because the one that has buried a father is already a man"he added.

"Thank you"Atule replied.

Ntoya took a piece of calabash and poured some of the 'da molga' from the pot. He poured a portion from the calabash onto the earth as a sign of respect to the gods. After drinking that full calabash, Ntoya set off to begin the firing. All the children that stood by started to flee. Some took refuge in the arms of their mothers. A ten gun sound was a sign that the funeral would be great. Atule was happy within. With the stock in his hand, Ntoya would fire all the ten metal rod in a very fast manner as to produce a rhythmic but powerful sound that would alert individual far and near that the funeral of Mba had commenced. When the final gun fire goes, Ntoya would jump up and stump the ground chanting the name of Atule's great grandfather, Mba Aquee. History has it that this great grandfather was a very strong man who fought to protect members of his clan. He lived

at a village called Gbere while some of his brothers settled at Teshie. It is told that Aquee was travelling one day on foot from his village to Teshie. While going through Zebilla, he caught up with some men of the town who tried to molest one of his grandsons. He took them on and beat them to the pulp. Word had reached his brother at Teshie about what happened and Akolba, his brother, set out to assist with the beating. Aquee met him on his way and asked why he should bother coming. "These were just little rats! I have dealt with them" Aquee had said. When Ntoya had done what was supposed to be done, the actual ceremony of the unroofing of the grave was done by the family and the elders of the community who gathered.

That evening, Anyaan held a fowl and performed libation when the unroofing of the grave which had been covered with thatch was done. . 'Sagbo' and water(Zielog Sa-ab) was prepared and kept in Mba's room. It is expected that the soul of the deceased would come and consume the sagbo and water. It is a way of providing the deceased strength to journey to the land of the ancestors. The first day was for the slaughtering of animals. Atule, together with nephews, in-laws, and grandsons displayed their animals. Atule's uncle was dazed at the fact that he was slaughtering a bullock for the funeral of his late father. He also paid about fifty cedis to the local violin player, Anaaf Kuguut.

The day was a busy one. There were rituals performed for the first day of the funeral. Then the women were busy with the preparation of food and supply of water. Then Atule retired for a

nap during the early evening. He was awakened by a silky voice at late evening. There stood a very dark and beautiful young lady. She was Mbama. She was the daughter of a close friend of Mba. She had sat the entrance exam to the teacher training school at Navrongo, a town many kilometres to the west of Atule's present home. She had offered to help Atule's mother in her yard during the funeral. Mbama brought Atule a bowl of 'sagbo' and soup to match. She informed Atule that his meal was ready. As she bent down to serve the food for Atule, his eyes caught up with the cleavage which sent blood running within his vessels to his manhood. He swallowed saliva as though he had something palatable in his mouth. "What a woman she will make if I get her. Am I not grown to marry?" he thought. He tried to overlap his legs as a way of suppressing his manhood. Nature has a way of bringing opposite sex together. It is hard to find how the desires of the two merged. Atule also realized that Mbama had a glimpse of his manhood and become static. "Mbama!" called Atule's mother. "Yes!" came the response. Within seconds she had disappeared as she had come.

The whole night, the funeral ground was fired up by the various grouping of individuals that listened to the griots play the 'gonje'. There was enough food and drink to spare. Wearing a nice piece of 'fuugu', Atule danced to the admiration of all who had gathered. He was gingered by knowledge of Mbama's likely presence. The entire funeral ground was vibrant. No ear could dismiss the nice tunes that emanated from the 'gonges' neither

could the mouths dodge the tasty pito brewed with the finest malt from these hinterlands of Northen Ghana. The crowd had fun all through the night.

The next day, the last rounds of rituals were performed and a caretaker found for the widow and children from among the deceased's brothers. The choice of caretaker must be exercised by the woman. She is normally influenced in this decision by the children who normally prefer an uncle who will leave them in peace and not chase them around for their father's wealth. The choice here was Abugri, the half brother of Mba though Anyaan will obviously had been the choice had he behaved well when his brother died. But his seizure of some animals of the deceased before the funeral put him in bad position. Thus, Mba's funeral came to an end, "kuutnaaya" it is usually said. The kuur-poosuundaar (day of greeting the funeral) will follow the next day.

After all had dispersed, there remained Amaltis' widowhood period which would be for forty days. Atule's mother sat in a thatched, round room most of the time. She was to observe her widowhood for forty days. She sat on that raffia mat with her legs crossed over each other. That exposed the natural beauty in her. She was dark in complexion with red lips. The calabash she held in her hand, 'pokoornwan,' made her look like a beggar sitting at the gate of a temple. Atule watched her with mixed

feeling. He detests customs that discriminate based on gender. But he held the opinion that the culture of a people must be transferred to unborn generations.

Picture of a Widow sitting with calabash.

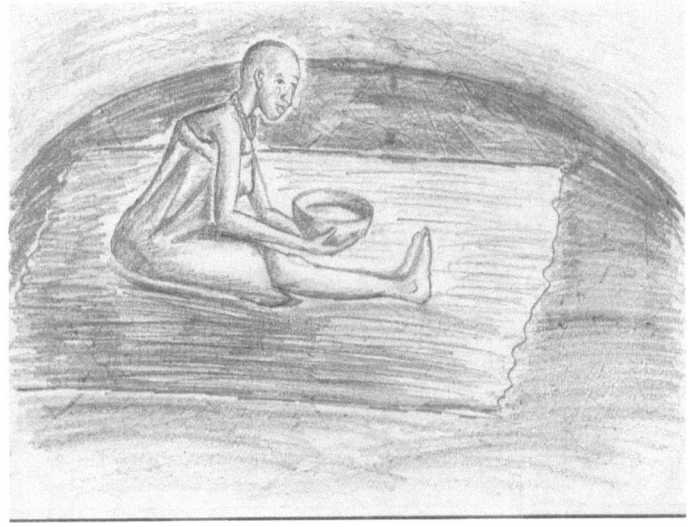

At the end of the forty days, she will go round the community market four times to signify to all that she had finished mourning her husband. Her period of confinement was over. Her head was shaved and a widow's strimps, 'porkoorwiis,' that were put round her waist were to be removed.

Amaltis fulfilled all these requirements of tradition. As she passed through the door of her husband's compound, tears dropped from her eyes. Atule went near and consoled her. If she had failed to pass through, she would have been considered an adulterer and would have had to confess the name of her partner in crime so a ritual of purification would be taken before she is able to enter the house. This occurred before the "we-eb daar" (day of slaughtering animals)

CHAPTER FIVE

AMALTIS' DESIRE

Some weeks after the funeral of Atule's father, Amaltis sat her son down to discuss what she thought was the most important thing affecting the home.

"Atule my son, you have done my husband and myself proud. Your father will be happy in the land of the ancestors. But you have now grown. Isn't it true?" she asked.

"It is true mother." Atule said.

"I could not have done all the chores during the funeral without the help of your sisters and Mbama, my daughter." She smiled. In most African traditions and among Kusasi, mothers who prefer their sons marrying certain ladies address those ladies as their daughters. This indirectly draws the attention of their sons to the choice they have made.

"I therefore need a help because very soon your sisters will leave for their husbands' homes. I also need my own grandchildren to put on my labs before I join your father one day. Go and think about it and take action. Mbama is really a

beautiful, humble, and educated girl any woman will want as a daughter. Go and think about everything I have said" concluded Amaltis. She had hit her point and did not want any trouble with today's modernized children raising objections when she herself saw none. Atule nodded his head signifying acceptance.

The Kusasi practice the patrilineal family system. That by implication means that any individual belongs to his father's lineage. However, it would be the sons who would automatically remain in the house. The females would marry and belong to their husbands. By this, children born by the females are usually not considered as part of the family. Mothers would therefore always wish that their sons marry many women to beget them grandchildren to play with. This was greatly anticipated by Atule's mother. Though Atule knew it was time to approach Mbama, he had no clue what to do or say. He had not done that before. At evening, Atule left for the new well to fetch water with two metal buckets. At the well was Mbama.

"Good evening!"Atule greeted.

"Fine evening" she responded twisting her third finger in the other hand. Her face gazed at the ground. He took a good gaze at her and realized her naturally endowed beauty was what attracted his mother to her. Mbama was a lady worth dying for. She offered to carry the water home for Atule but he declined. He promised to meet her at the wrestling competition which would take place at the chief's palace. They both departed. The

facial expression on each and every one's face was indicative that they had enjoyed that moment they just met.

It was quite a moony night when most had gathered at the chief's palace. As a child, Atule only knew that the event was a platform where individuals wrestled. He stood still watching the wrestling bouts that took places. A young man called Gbiginbaat, meaning 'lion idol' defeated all his contenders that night. He then threw out a challenge to all who had gathered, 'is there any challenger?' The whole place was silent and at a point in time, Atule jumped into the ring. Little did he know that someone had held his hand. The force with which he pulled off his hand made that fellow to fall to the ground. They engage each other for close to an hour. Whereas Gbigin Baat applied full strength, Atule, though strong, was very skilful. Atule was born a one boned individual meaning his radius and ulna was fused together. Such individuals are said to be very strong by nature. Gbiginbaat held Atule by his waist and swung him towards his right side. He stooped low to pounce on Atule but with a swift turn, Atule supported his body with his left hand and jumped up. Amongst the crowd stood Mbama who would bend down whenever Atule went down. That fast turn made by Atule gave him the opportunity to grasp Gbiginbaat by his ankle and toppled him. There was shouting all over, Mbama run and hugged Atule. He felt the softness of the balls on her chest. Blood run through his vein descending once more into his manhood. Hugging was unusual in the village of Teshie because

it was considered a foreign culture. Individuals who did such were considered spoiled.

The moon started to retard to its abode. Darkness began to take cover and sleep crawled in the bodies of men like a tick on the body of a dog. Vision was blur. The hands of the two clinched to each other firmly like a placenta attached to a womb. Only voices of dogs and creatures of the night could be heard. Fear engulfed Mbama like a bullet fired into a person's tissue. She held Atule firmly as her only savior. At her waist he felt the presence of pairs of strings of tiny objects. He remembered grandfather's statement that touching the beads of a woman is like listening to a solo music. "What a soft area" he thought.'

"Oh! My leg,"Mbama said.

"What happened?" Atule inquired.

"I fell at the chief's palace," replied Mbama.

"How?"

"Oh don't worry, I would be ok."

"I am very sorry, my dear. Were you the one that held my hand?"

"Yes."

"I am sorry. That man made me very angry. He thought we are all weaklings. He should not let his stature deceive him."

"I am proud of you. I thought you had forgotten the tricks of wrestling owing to your education."

She felt the force which Atule's manhood was exerting on her thighs. "When will you ..." she had not completed the question when Atule placed his finger on her lips. He was not a womanizer but gathered a few ideas of how to handle woman through foreign movies that he watched at school. His tongue rolled and his hand went down towards Mbama's undergarment. "Oh sorry, we shouldn't be doing this now!"said the lady. They held each other's hands firmly and drifted towards Mbama's house.

'Baa ZomYela' was a dog whose name mean, 'Even a dog must fear trouble."Mbama's father had reared it for five years. It barked profusely at the instance of the simmering voices and dragging feet. A touch light pointed at the direction of the two. They immediately disjointed their hand to avoid being caught. "You have stayed too long" a voice uttered, "next time don't repeat that", he cautioned. "Ok, dad" Mbama said.

"My son, how are you?" Mbama's father said to Atule.

"I am doing well sir" he responded.

"Hurry home because it is almost midnight" he advised.

Atule wondered if his educational status played a role in Mbama father's kindness towards him or that he was naturally so. But after much thought he concluded that the man was a

naturally good hearted fellow who was one of the few people Mba consulted during his life time. He was therefore a second father to him. He thought he was a great man who loved people. He left his family house and built outside, though he is the eldest. All he while, Atule got home without realizing it. He jumped unto his bed and slept off.

Chapter Six (6)

MBAMA'S BRIDE PRICE

Days before Atule honoured the Health Service's directive that he should start work as a nurse in another region of the country he approached his uncles to discuss plans for the marriage of Mbama. Anyaan was particularly shocked. "Oh, you want to marry!" Anyaan said. The manner in which he stated what Atule had told him and his other uncles sent shivers down the spine of Atule. Atule wondered if he was his father's own brother. Though Atule had learnt that his grandfather was a kind-hearted man, Anyaan's behavior seemed out of touch with the life of his legendary father. Anyaan was obviously not ready to part with anything in the name of marrying girl for this stubborn child of his demised brother though he knew it was his responsibility.

"Let him dowry the lady himself. If he could kill a bullock at his father's funeral, then he can do more to redeem his foolish pride. Nonsense!" Anyaan thought.

The glaring disinterest of his uncles worried Atule much. Except Abugri, all the other uncles of Atule appeared unconcerned about Atule's decision to get married. That was when Atule decided to consult his mother. One must never run out of ideas if his mother is alive. That evening Atule went in and discussed what had transpired between him and his uncles with his mother.

"Don't worry my son," she said, tapping him at the shoulder, "a man who knows true tradition will always carry the load of love with ease. It is man's lust for wealth that has made us forget where we came from. In the Kusasi custom, you only ask for a woman's hand in marriage by presenting the drinks, kola, tobacco, and hoes which are the important items. She will then stay with you and after she births children, you go ahead to pay the dowry of four cows.My brother and I will work on this for you." She concluded.

True to her words, Amaltis honoured her promise. Atule's uncles went to Mbama's people and negotiated the marriage. Within days, all was concluded for the young girl to move in to her new home. She was to be brought on the evening of a Teshie market day in the company of women of Atule's larger family amidst dancing and singing. Atule borrowed a twelve battery tape from his friend to make the entertainment even more enjoyable. The twelve battery tape which had speakers at the lateral ends echoed the tunes of popular music of the day. The whole yard was filled with august visitors from neighboring houses. There was much to eat for everyone who came. Atule had killed a goat and some chicken with which his mother used to prepare varieties of rice dishes.

As midnight approached, the visitors started to fall out. The courtyard becomes darker and darker. Mbama, who wore a blouse and a new women's wrapper was almost dozing off. She seemed to have waited for Atule for too long in the room.

"My dear, you are welcome." Atule announced.

"Thank you." She said. They watched each other closely. Words at a point in time had vanished from their mouths.

"I am all yours" she said.

"I am also yours" he replied.

"What shall we call him?" He asked.

"No, it will be a her."

"No, a him."

They argued playfully as they undressed unconsciously. She was receptive but frightened. Atule knew he had to be gentle with her. He knew more about gynecological issues than she did because of his training. He wanted none of those.

After consummating their union, the two lovebirds spoke about the future. Mbama was intent on pursuing her teaching dream. She will apply and write the entrance exam to the teachers college again when she had weaned her baby. Atule had nothing to say but that he will start work in earnest. They thanked God they were adults. Ill-matured girls who started sex life early usually got pregnant prematurely. They sometimes die during childbirth. Others who don't get pregnant end up acquiring HIV/AIDS. They at a point in time, felt like they were babies given some hot baths. Mbama placed her head on the chest of Atule and off they dozed.

In the end, Atule carried the burden of performing the funeral of his father and dowering his beloved Mbama. Only the support of his mother purged him on. His maternal uncle's understanding and support was all he had throughout. The cattle, sheep, goats and other animals that he used to facilitate all these events were all from his possessions with his uncle. His uncle, Anyaan, had taken custody of all the cattle and sheep that could make the life of his mother and siblings better. The family had to start all over again. The act of seizing the wealth of dead relations even while their children are alive is a practice jealously guarded by most miscreants in families. It is one of the ills of our modern society. When a man dies, relatives of the deceased try to hi-jack his or her property while abandoning other responsibilities to the children. Clinched to the one his heart attracts, Atule slept off into a dream.

They raised five beautiful children- three boys and two girls. Then in the district capital at Zebilla, he established a clinic. They were a happy family. As the years went by, his body began to go frail. Thoughts of Anyaan and what he had done haunted him in those dying days. On his death bed, he called his lawyer and signed a will. His desire was that his generation would not face the cruelty he faced.

"Wake up my dear," said Mbama, "How was your night?" she asked.

"Great" he replied, "I had a dream."

"What was it about?"

"It was about us. It was that the ills of yesterday will not be repeated again in the next generation. That the hunger orphans and widows suffer will come to an end. That the humiliations my mother went through to mourn my father is far from you. That my children will not be subjected to the whims of irresponsible uncles" he was almost rhetorical. Mbama watched him and tears flowed from her eyes. As part of the community, she had heard and seen what this family had gone through at the hands of a tradition that gives uncles unwarranted power over poor orphans and children. He drew her close to himself and kissed her. They remained close to each other. After sometime, she tucked her hand into the space between his legs and played with him. He felt instantly hardened and began responding to her urge. As he did so, he knew that both knew this story so well. He knew she will not keep quiet about it. He knew she will tell the children. And he knew he will not repeat his father's mistakes.

Epilogue

When Mbama trained as a teacher, she took up the burden of campaigning against ill-informed customs and traditions. Her message reached far and wide through the radios that became popular with households. Atule knew that his single story was her motivation. He thanked God that at long last the breeze of civilization is blowing over a land steep in old practices that

discriminate the widow and orphan. God surely protects his own from hail stones if no one does!

Holding the quill with a frail hand
The ink drops with powerful sounds
Echoing to men of wicked hearts
Orphans and widows they must jealously guard
If their hearts remain in their wicked states
The ink will dent their worthless dreams.

Azurago Jonas Anafo

ABOUT THE BOOK

When Mbama trained as a teacher, she took the burden of campaigning against ill-formed customs and traditions. Her message reached far and wide through radios that became popular with households. Atule knew that his single story was her motivation. He thanked God that at long last the breeze of civilization was blowing over a land steep in old practices that discriminate the widow and orphan. God surely protects his own from hail stones if no one does. Behold the '**ARROW OF SUCCESS**', a short novel that will change your life.

ABOUT THE AUTHOR

Azurago Jonas Anafo is nurse by profession currently pursuing a Bsc. Physician Assistant Program at Kintampo College of Health. He is a motivational speaker and founder of Save an Organ Foundation, a non-profit Organization.

He is the author of the book- "OUSTING FEAR", and a member of Ghana Association of Writers. He is married to Rosemary and has a daughter(Happiness).

GLOSSARY

Asuul – The invisible wise rabit in Kusaal folktale

Atule – Means Opposite

Ayelatoya – Means the one whose matter is difficult

Baagre – idol/god

Bo-ot – Local silos built with mud

Daam – Local beverage drink

Doo dim – Care takers of the room

Fuugu – Local smock

Gbang - Animal skin

Griot – One who recalls history through music, poems, stories and dancing

Koombeet – A mixture of hot water and herbs

Koose – Beans cake

Kusie – Small hoe

Mahsa – Millet cake

Mus – Elephant grass

Pokoornwan – Widow's calabash

Saab – Millet or maize staple

Soong – Local mat

Taansoog – Bath room

Tampuut – Refuse damp

Wan – Calabash

Yoogkobiig – Grave animal

Yoognoa – Grave foul

Zaanyoor – Court yard

Zong – Medicine room

Zoomkoom – A local drink of flour mixed with sheabutter

www.ingramcontent.com/pod-product-compliance
Lightning Source LLC
Chambersburg PA
CBHW021440170526
45164CB00001B/317